001

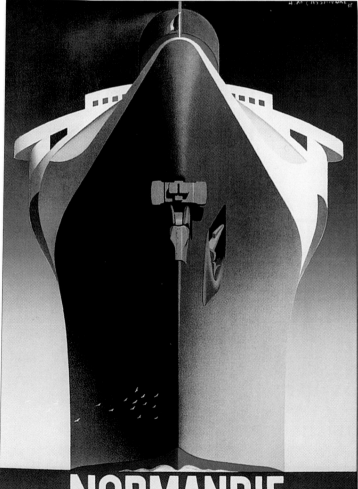

003

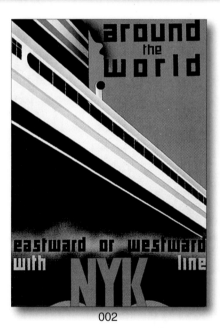

002

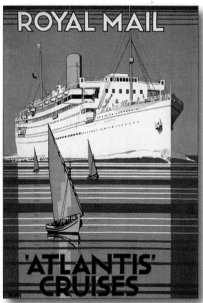

004

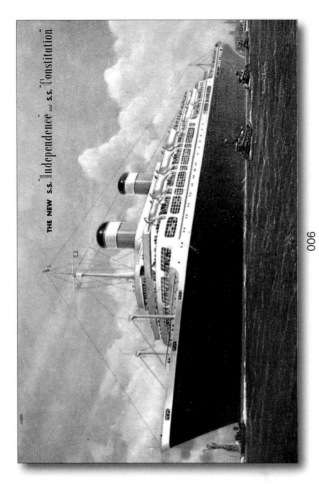

THE NEW s.s. *Independence* and s.s. *Constitution*

006

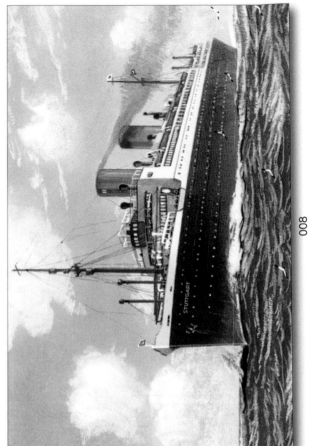

STUTTGART

008

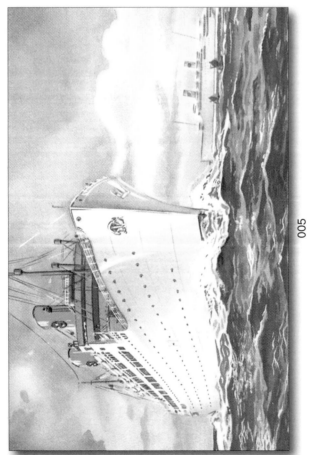

005

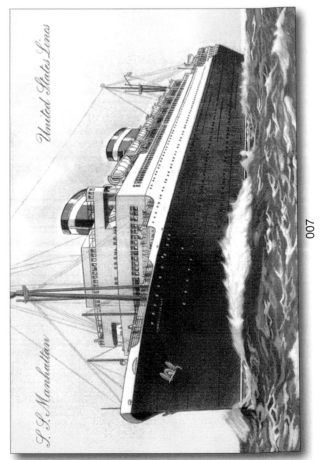

United States Lines

S.S. Manhattan

007

2

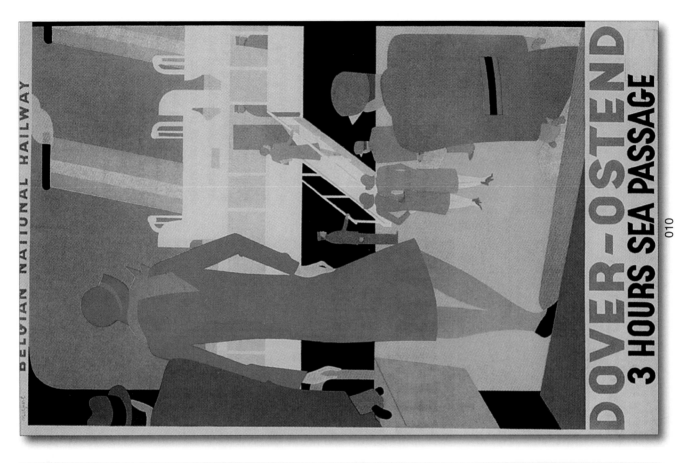

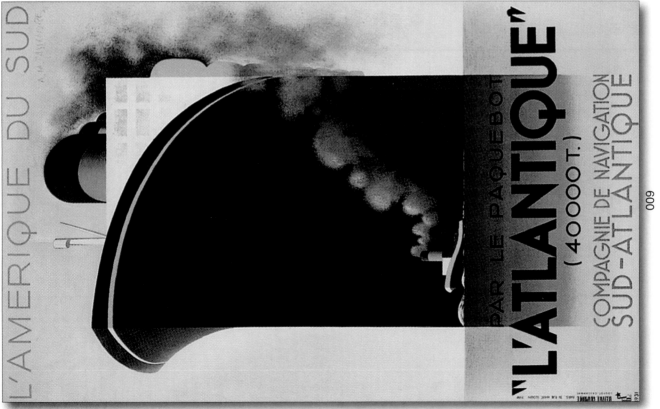

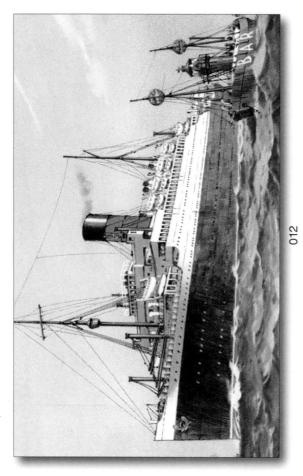

012

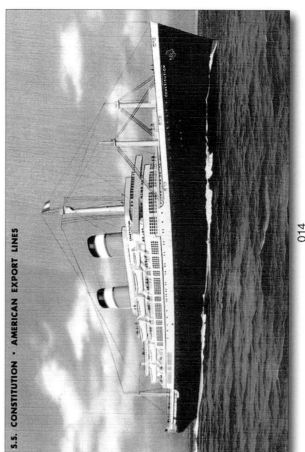

S.S. CONSTITUTION · AMERICAN EXPORT LINES

014

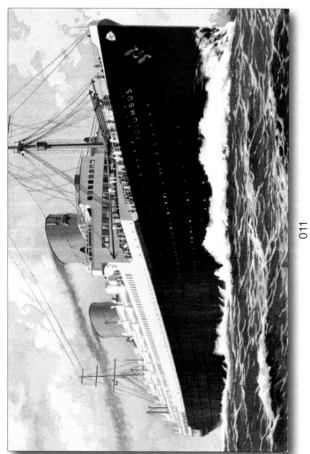

011

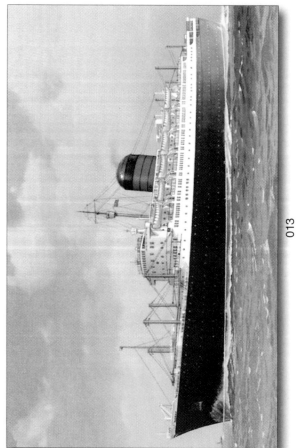

013

4

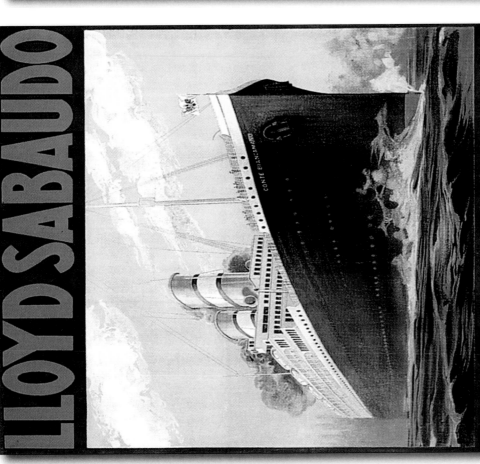

LLOYD SABAUDO

CONTE BIANCAMANO
CONTE ROSSO ★ CONTE VERDE
Servizi celeri di gran lusso per le Americhe

STAB. G. SCHENONE-GENOVA

015

NEW YORK
ANCHOR LINE
TO AND FROM
VIA MOVILLE (LONDONDERRY)
GLASGOW.

016

5

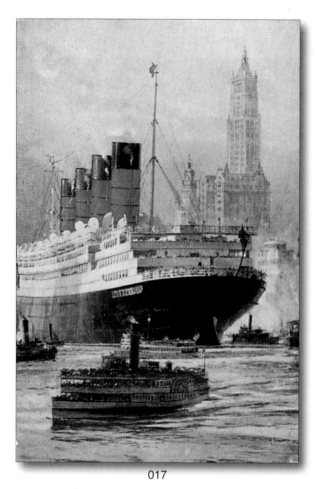

017

018

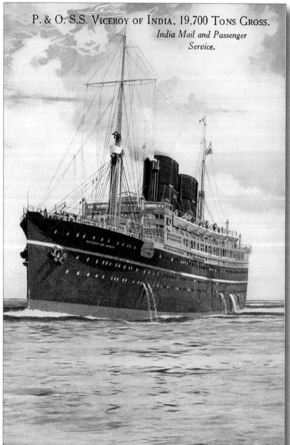

P. & O. S.S. VICEROY OF INDIA, 19,700 TONS GROSS.
India Mail and Passenger Service.

019

020

021

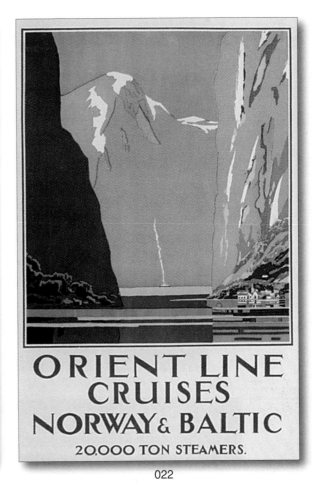

022

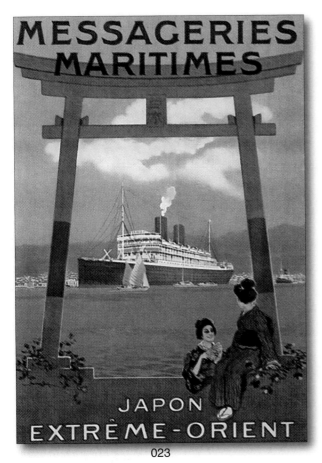

023

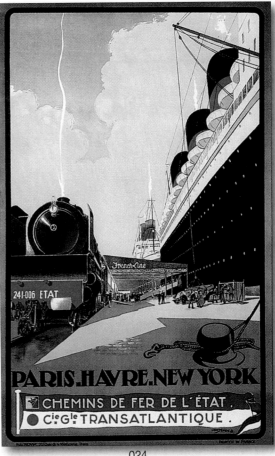

024

7

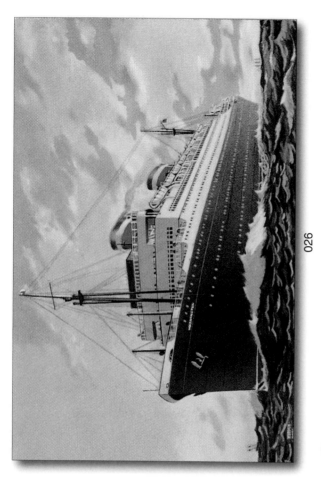

026

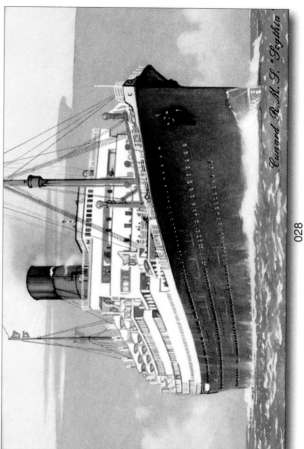

028

Cunard R.M.S. "Scythia"

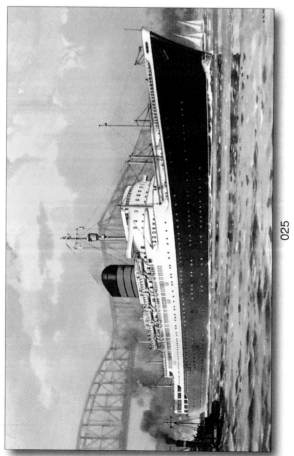

025

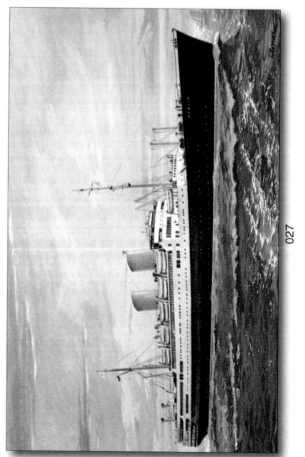

027

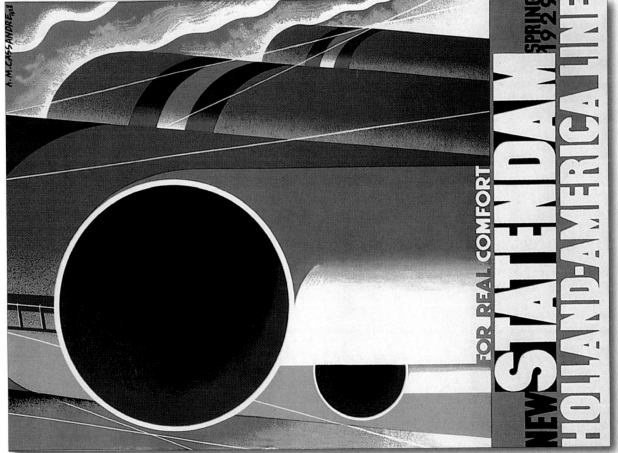

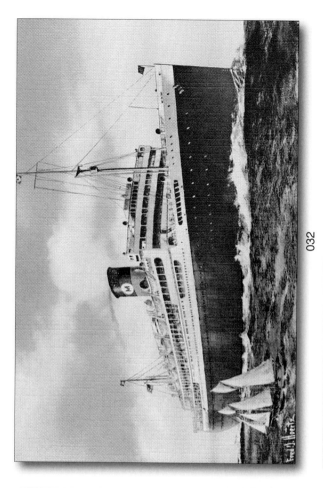

032

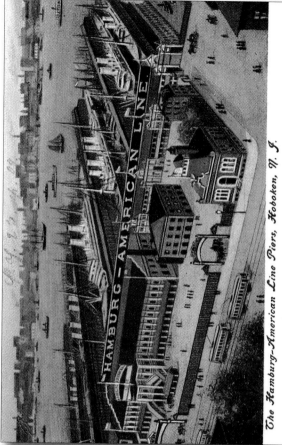

The Hamburg-American Line Piers, Hoboken, N. J.

034

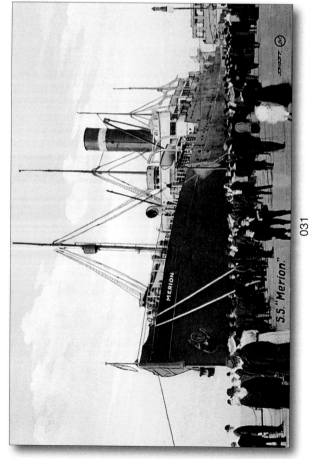

S.S. "Merion."

031

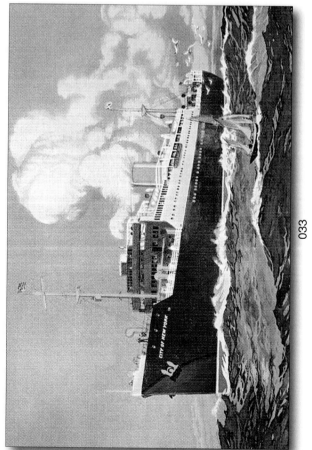

033

10

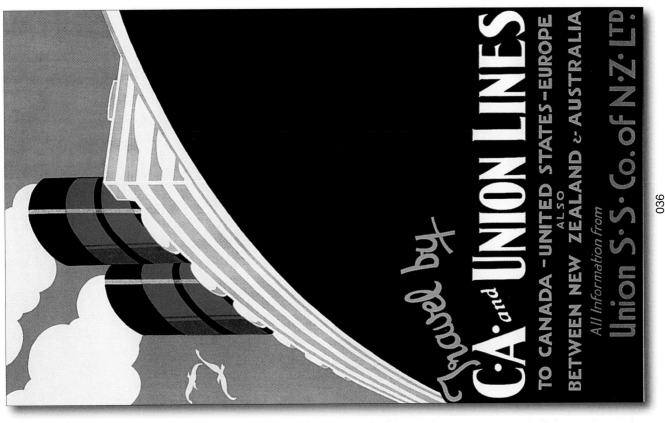

036

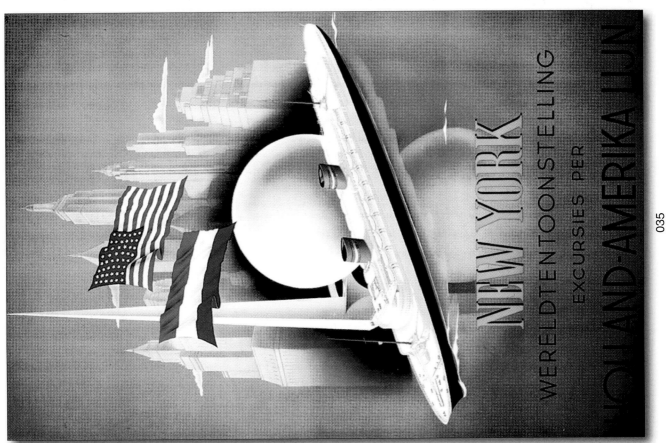

035

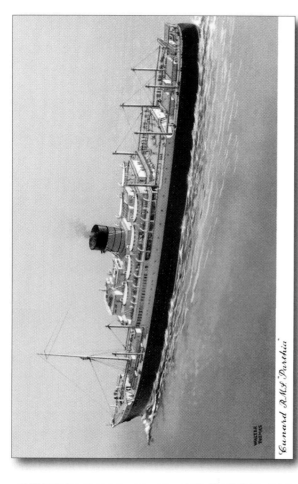

037

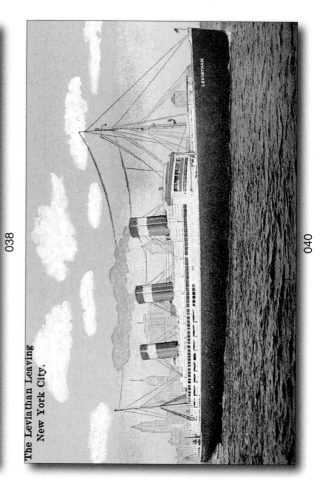

Cunard R.M.S. 'Parthia'

038

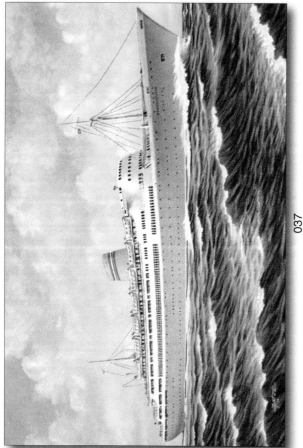

039

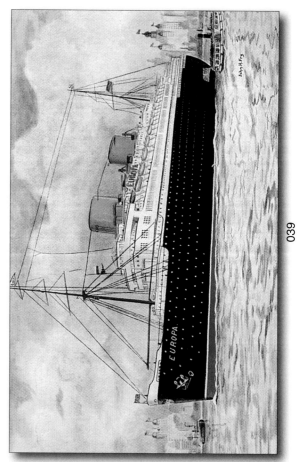

The Leviathan Leaving
New York City.

040

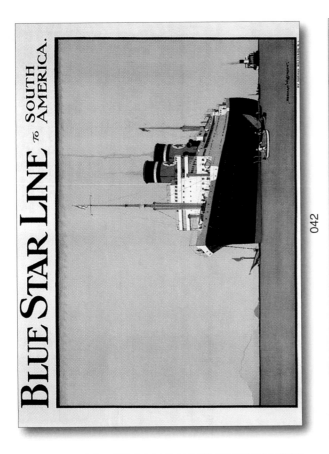

042

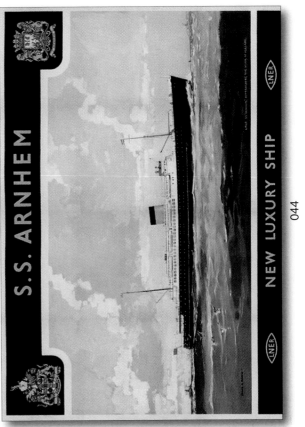

044

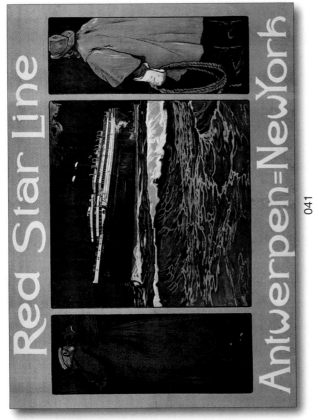

041

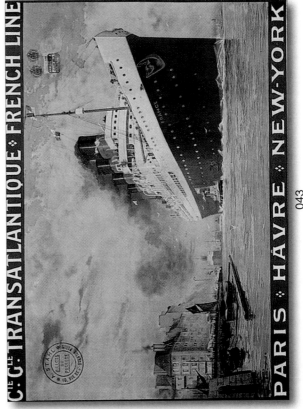

043

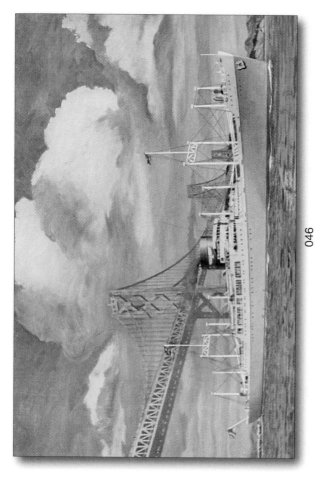

046

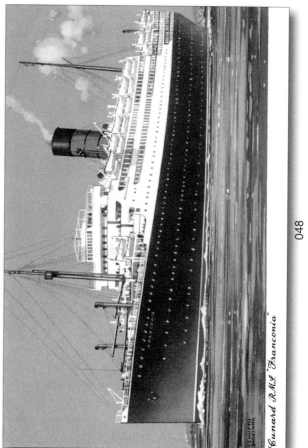

Cunard R.M.S. "Franconia"

048

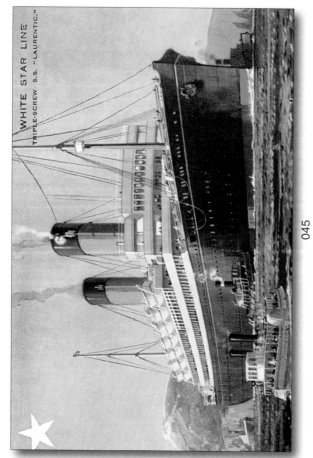

WHITE STAR LINE
TRIPLE-SCREW S.S. "LAURENTIC."

045

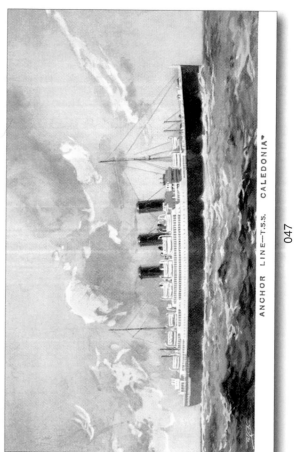

ANCHOR LINE—T.S.S. CALEDONIA

047

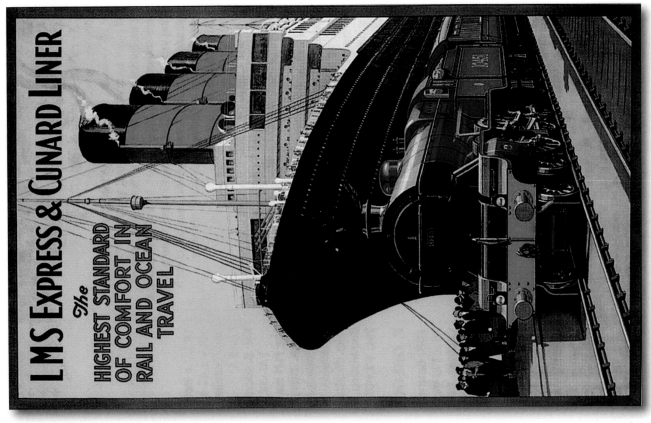

050

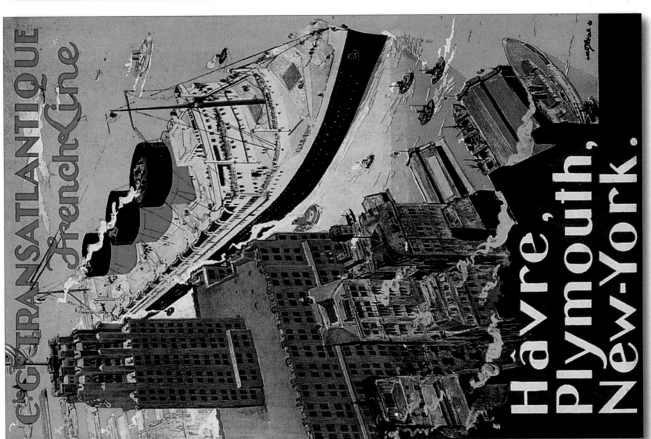

049

15

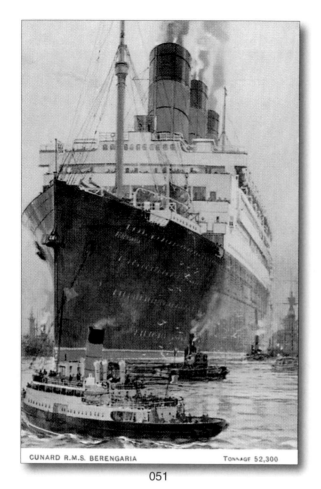

CUNARD R.M.S. BERENGARIA TONNAGE 52,300

051

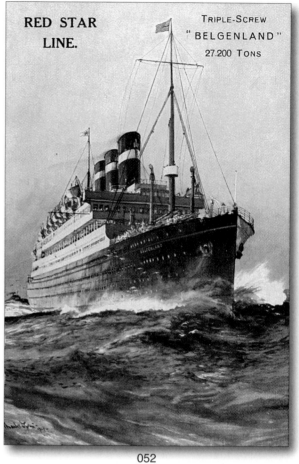

RED STAR
LINE.

TRIPLE-SCREW
"BELGENLAND"
27.200 TONS

052

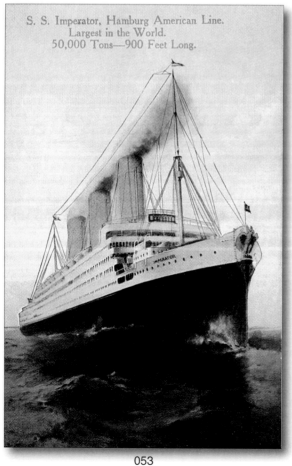

S. S. Imperator, Hamburg American Line.
Largest in the World.
50,000 Tons—900 Feet Long.

053

054

055

056

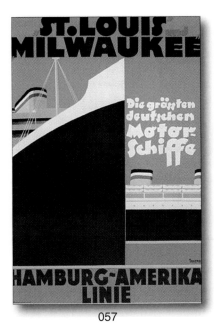

057

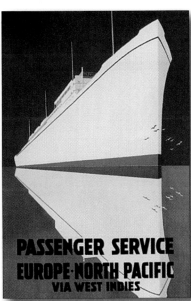

058

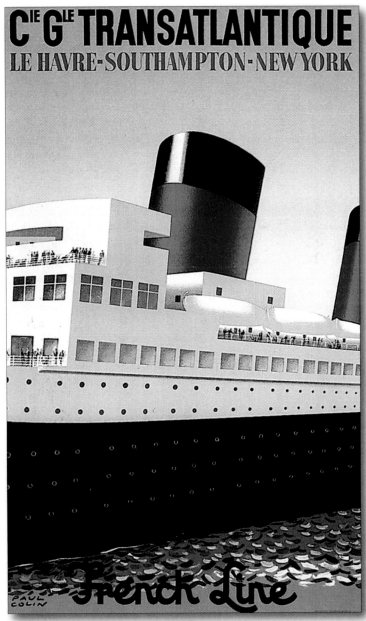

059

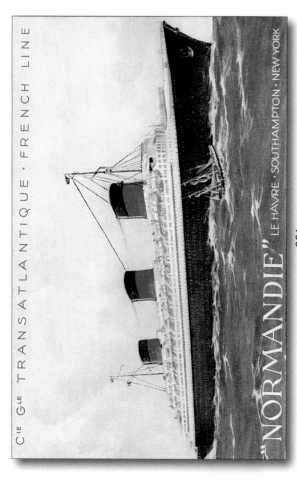

CIᴱ Gᴸᴱ TRANSATLANTIQUE · FRENCH LINE

"NORMANDIE" LE HAVRE · SOUTHAMPTON · NEW YORK

061

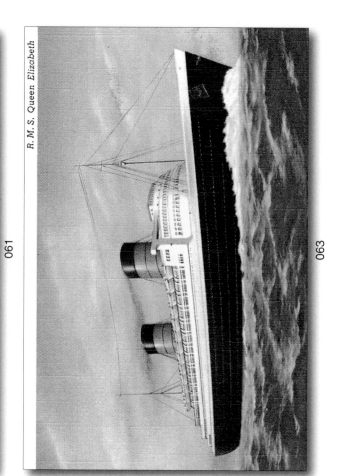

R. M. S. Queen Elizabeth

063

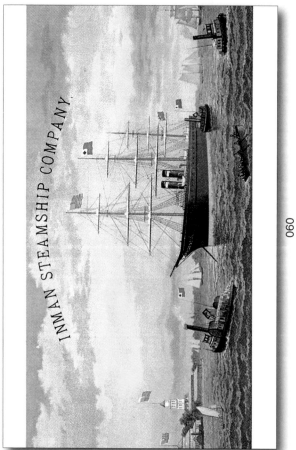

INMAN STEAMSHIP COMPANY.

060

062

Comfort-Courtesy-Safety-Speed
UNITED STATES LINES

065

SUÈDE
VIA LONDRES

Billets à bas prix de Paris
à toutes les Stations Suédoises

s.s. SUECIA
s.s. BRITANNIA
s.s. PATRICIA

SWEDISH LLOYD GOTHEMBOURG-SUÈDE

064

19

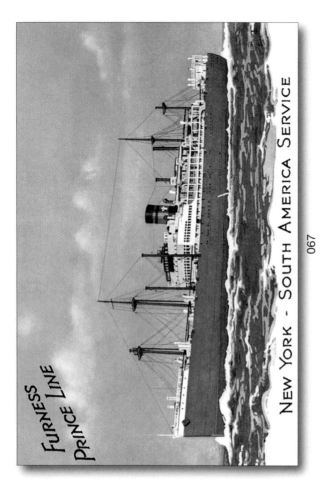

FURNESS PRINCE LINE

NEW YORK - SOUTH AMERICA SERVICE

067

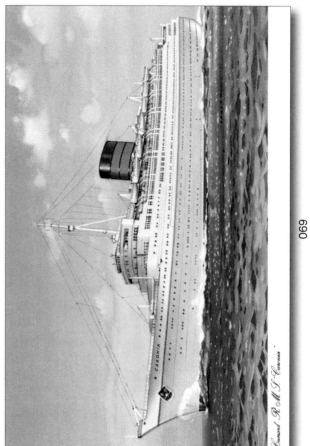

069

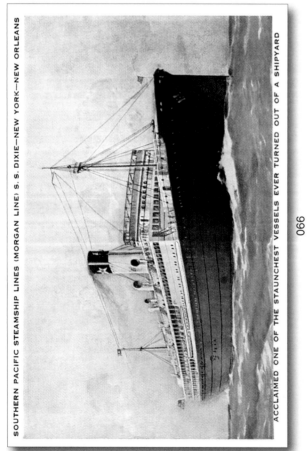

SOUTHERN PACIFIC STEAMSHIP LINES (MORGAN LINE) S. S. DIXIE—NEW YORK—NEW ORLEANS

ACCLAIMED ONE OF THE STAUNCHEST VESSELS EVER TURNED OUT OF A SHIPYARD

066

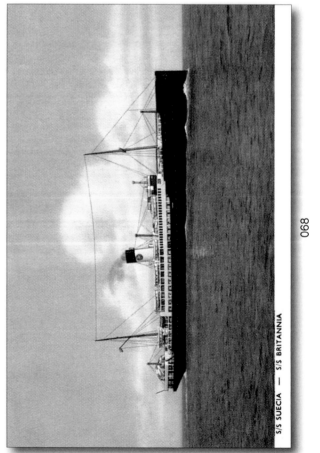

S/S SUECIA — S/S BRITANNIA

068

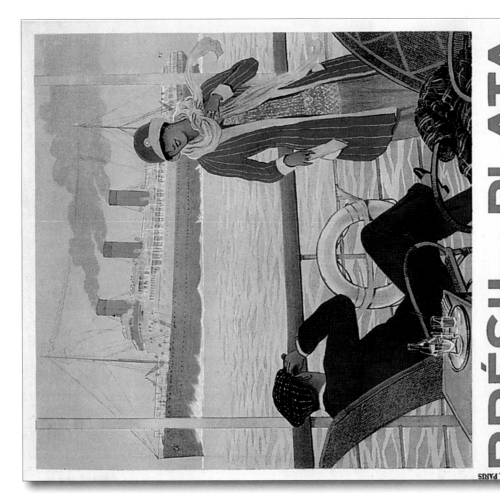

BRÉSIL - PLATA

PAR LES COMPAGNIES DE NAVIGATION

CHARGEURS RÉUNIS
SUD-ATLANTIQUE

071

N.R.MONEY, 6 Rue de Madrid, PARIS

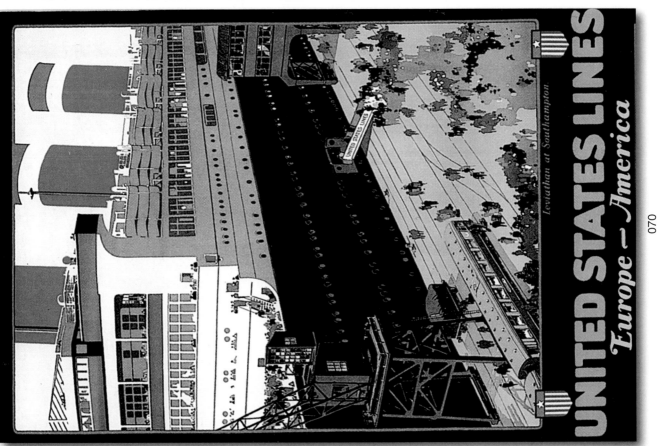

Leviathan at Southampton

UNITED STATES LINES
Europe ~ America

070

21

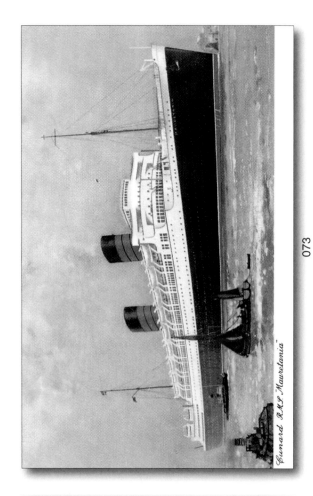

Cunard R.M.S. "Mauretania"

073

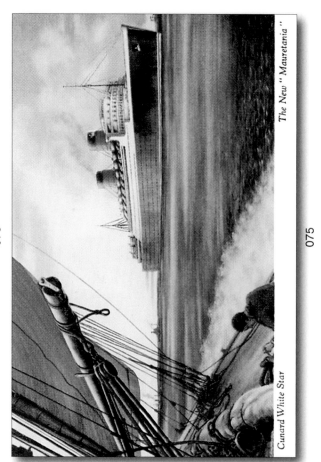

The New "Mauretania"

Cunard White Star

075

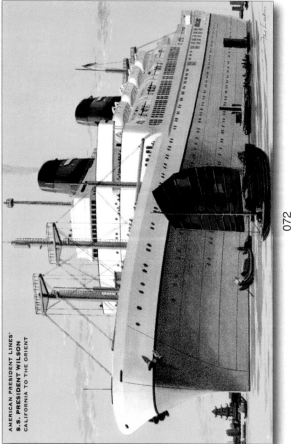

AMERICAN PRESIDENT LINES'
S.S. PRESIDENT WILSON
CALIFORNIA TO THE ORIENT

072

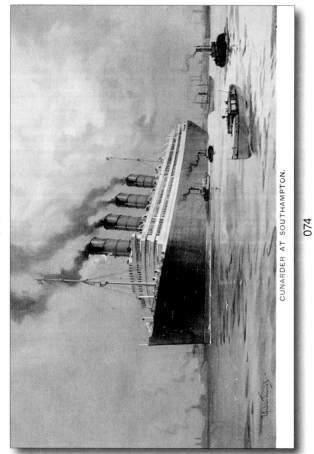

CUNARDER AT SOUTHAMPTON.

074

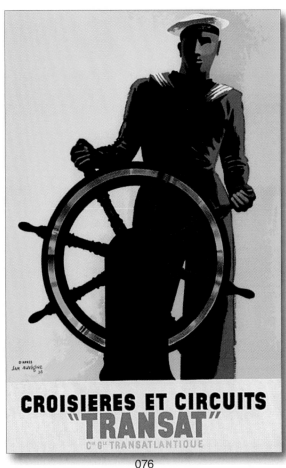

CROISIERES ET CIRCUITS
"TRANSAT"
Cⁱᵉ Gⁱᵉ TRANSATLANTIQUE

076

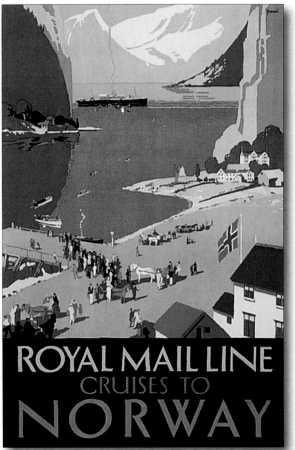

ROYAL MAIL LINE
CRUISES TO
NORWAY

077

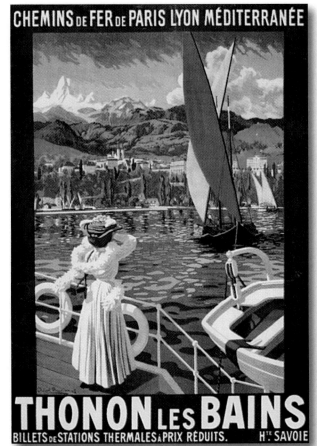

CHEMINS DE FER DE PARIS LYON MÉDITERRANÉE

THONON LES BAINS
BILLETS DE STATIONS THERMALES À PRIX RÉDUITS. Hᵗᵉ SAVOIE

078

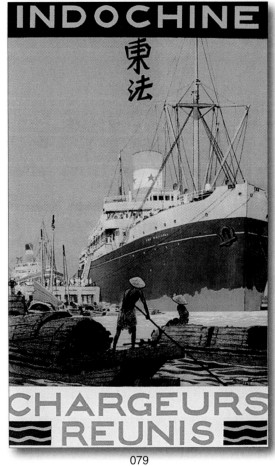

INDOCHINE
東
法

CHARGEURS
REUNIS

079

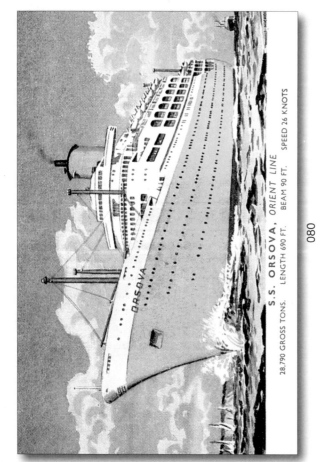

S.S. ORSOVA, ORIENT LINE

28,790 GROSS TONS.　LENGTH 690 FT.　BEAM 90 FT.　SPEED 26 KNOTS

080

081

MONTREAL FROM ST. HELEN'S ISLAND. MONTREAL. QUE.

082

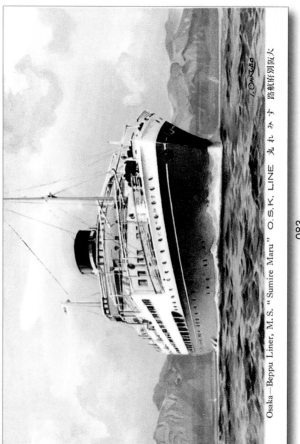

Osaka—Beppu Liner, M.S. "Sumire Maru" O.S.K. LINE　大阪商船別府航路　すみれ丸

083

24

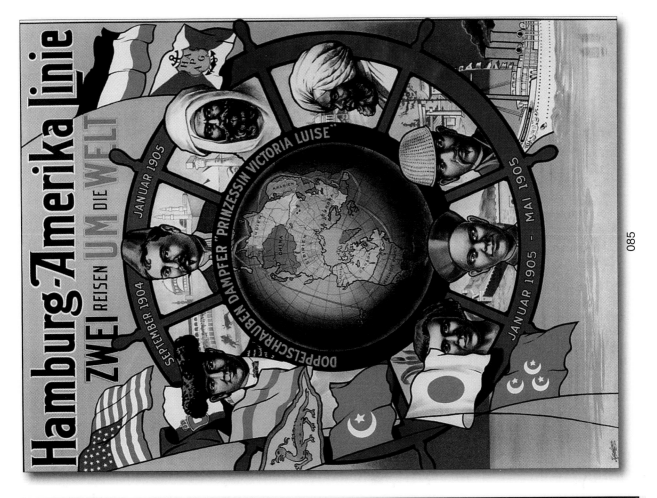

085

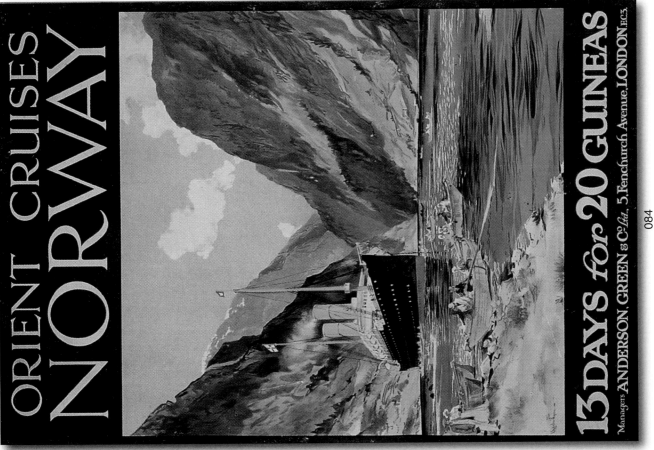

084

25

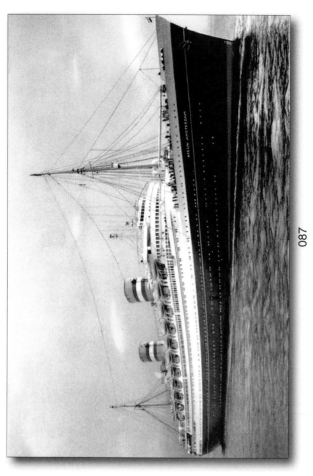

087

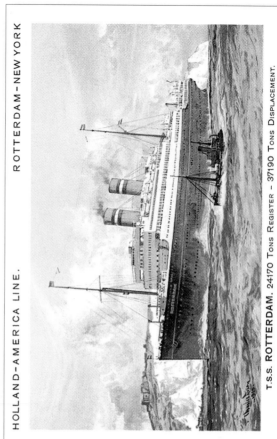

HOLLAND–AMERICA LINE.

ROTTERDAM – NEW YORK

T.S.S. ROTTERDAM. 24170 TONS REGISTER - 37190 TONS DISPLACEMENT.

089

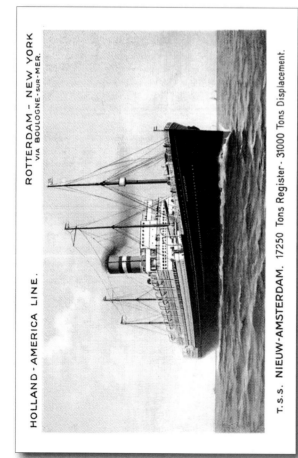

HOLLAND-AMERICA LINE.

ROTTERDAM - NEW YORK
VIA BOULOGNE-SUR-MER.

T.S.S. NIEUW-AMSTERDAM. 17250 Tons Register - 31000 Tons Displacement.

086

Cunard M.V. Britannic

088

090

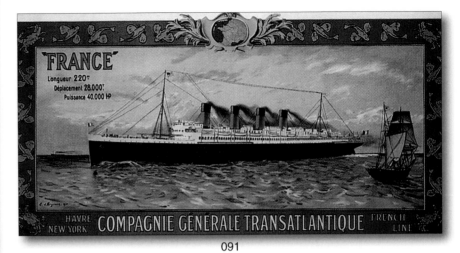

091

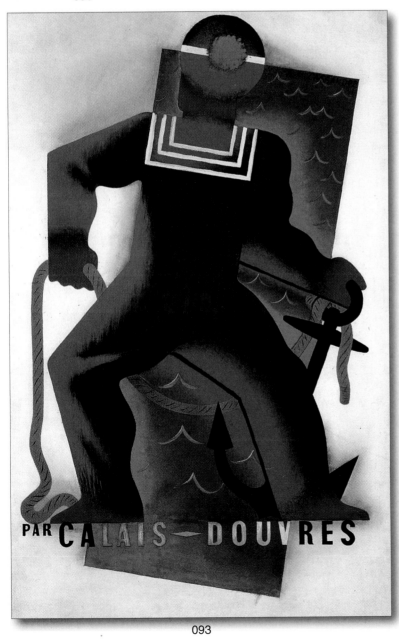

093

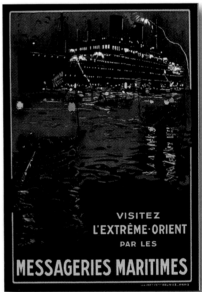

092

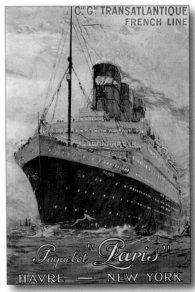

094

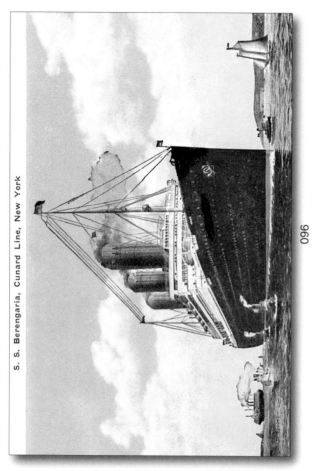

S. S. Berengaria, Cunard Line, New York

096

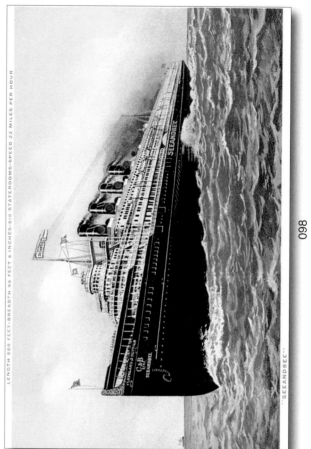

LENGTH 500 FEET·BREADTH 98 FEET 6 INCHES·510 STATEROOMS·SPEED 22 MILES PER HOUR

"SEEANDBEE"

098

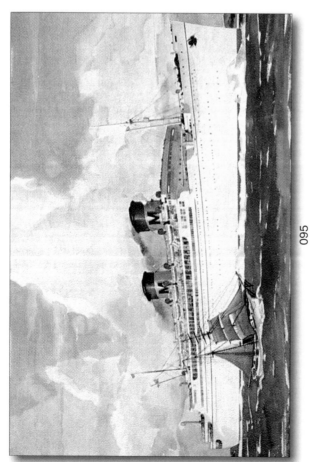

095

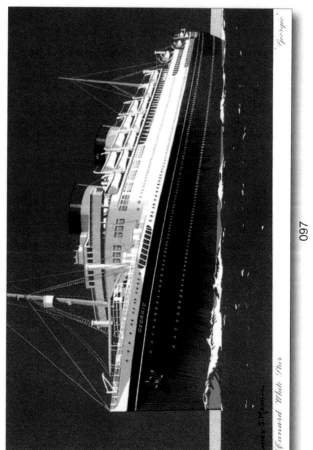

"Georgic"

Cunard White Star

097

28

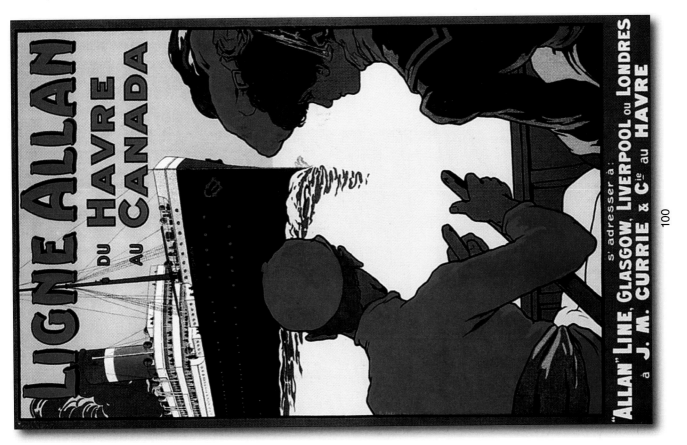

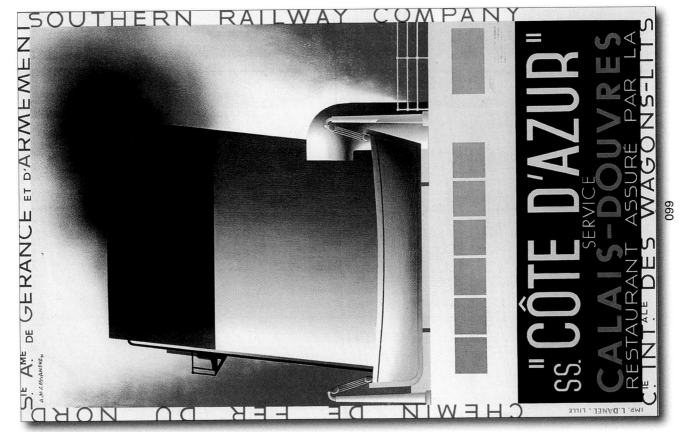

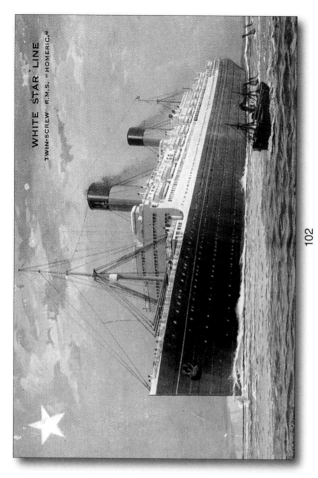

101

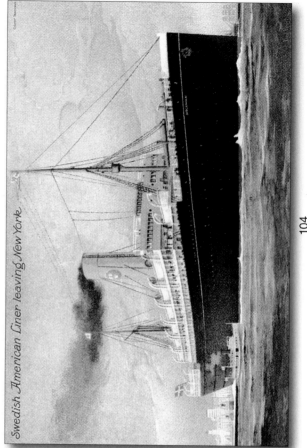

WHITE STAR LINE
TWIN-SCREW R.M.S. "HOMERIC."

102

CLYDE-MALLORY LINER APPROACHING JACKSONVILLE, FLA.

103

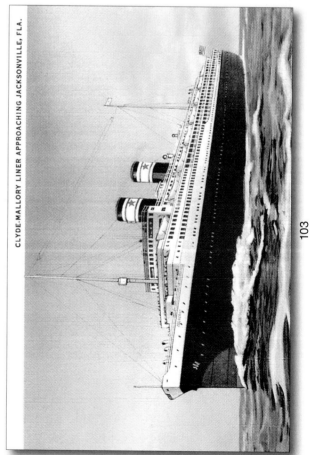

Swedish American Liner leaving New York

104

106

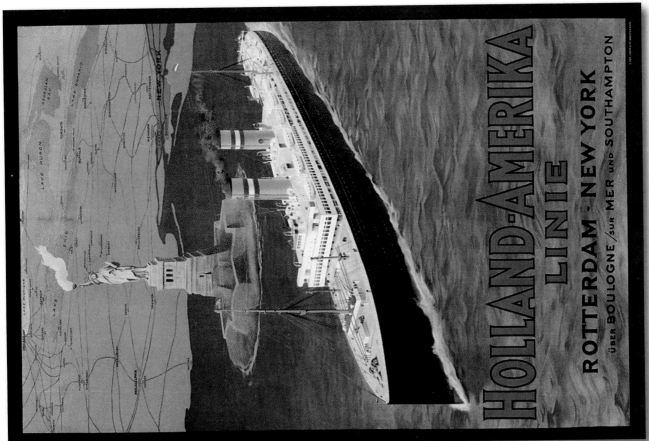

105

31

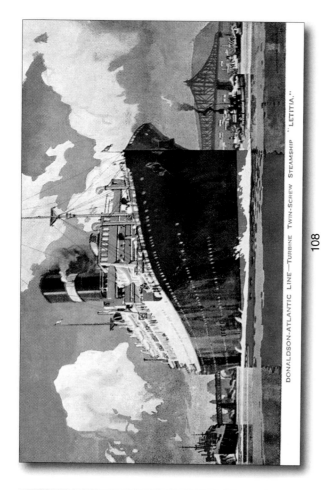

DONALDSON-ATLANTIC LINE—TURBINE TWIN-SCREW STEAMSHIP "LETITIA."

108

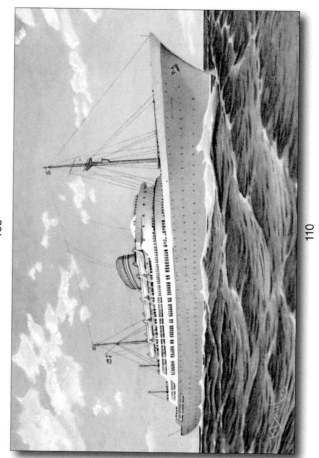

110

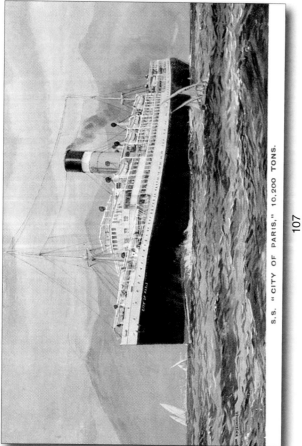

S.S. "CITY OF PARIS," 10,200 TONS.

107

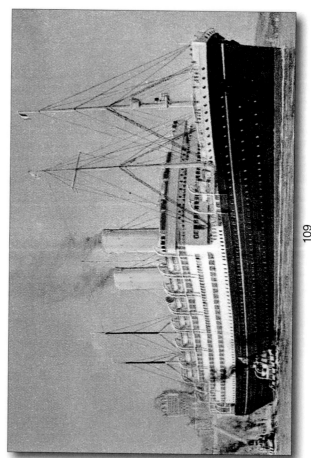

109

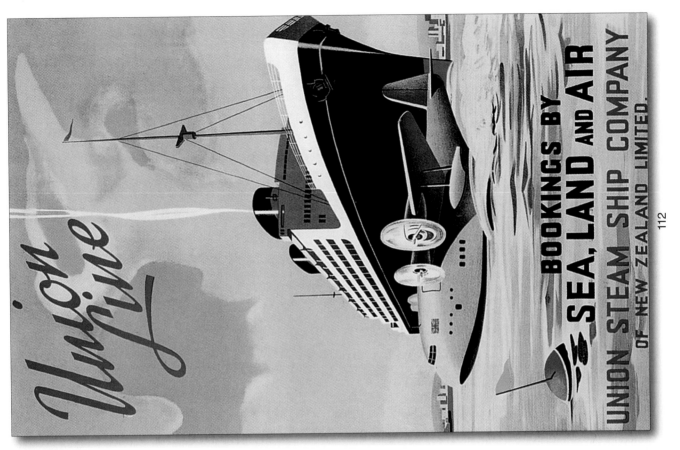

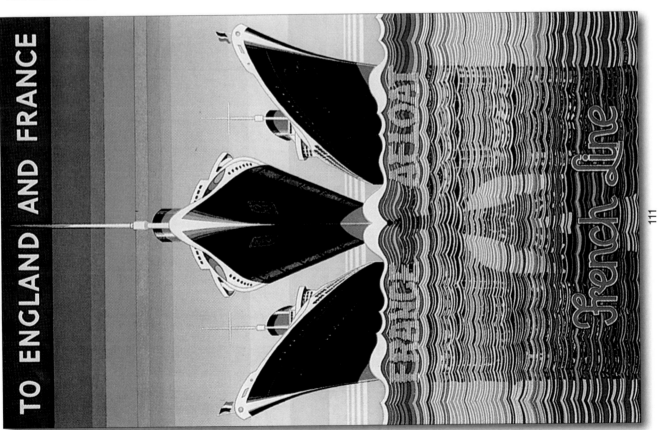

33

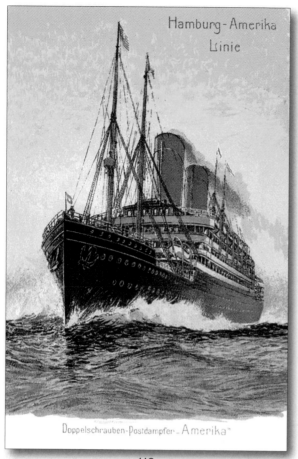

Hamburg-Amerika Linie

Doppelschrauben-Postdampfer „Amerika"

113

God guard thee from the dangers of the sea

114

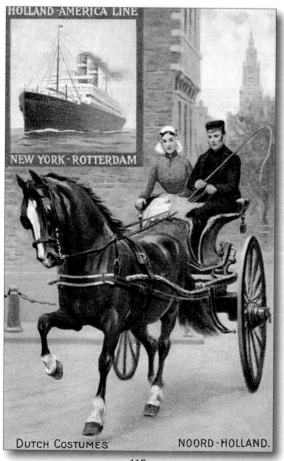

HOLLAND-AMERICA LINE

NEW YORK - ROTTERDAM

DUTCH COSTUMES NOORD-HOLLAND.

115

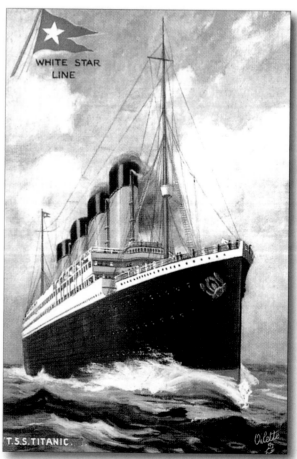

WHITE STAR LINE

T.S.S. TITANIC.

116

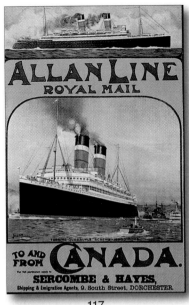

117

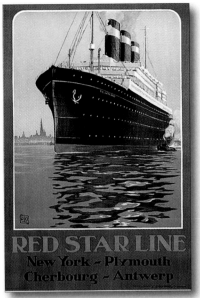

118

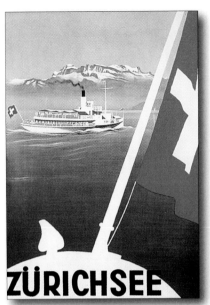

119

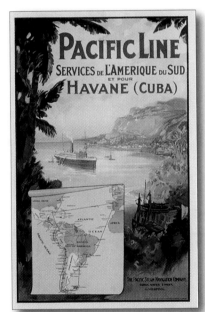

120

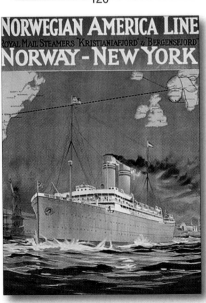

121

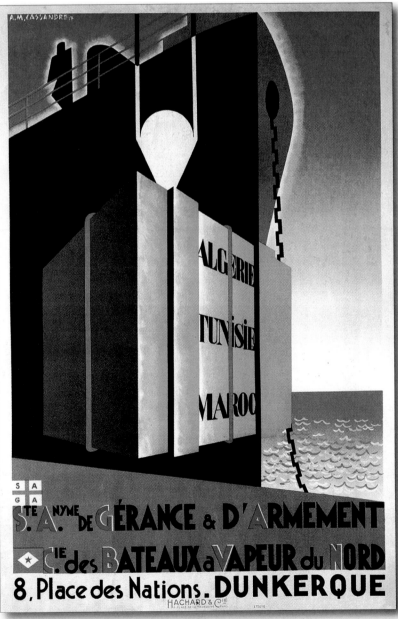

122

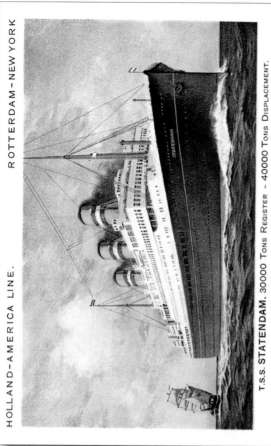

HOLLAND-AMERICA LINE.　　ROTTERDAM-NEW YORK

T.S.S. STATENDAM. 30000 Tons Register - 40000 Tons Displacement.

124

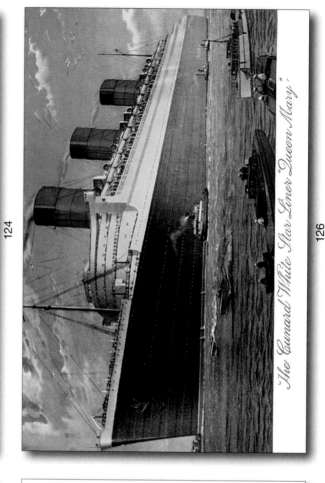

The Cunard White Star Liner "Queen Mary."

126

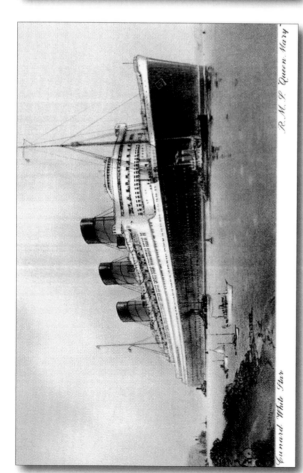

R.M.S. Queen Mary

Cunard White Star

123

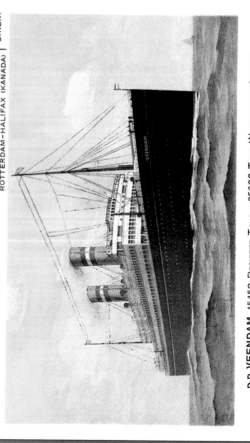

HOLLAND-AMERIKA LINIE.

ROTTERDAM-NEW YORK
ROTTERDAM-HALIFAX (KANADA) } DIREKT

D.D. VEENDAM. 15450 Register Tons - 25600 Tons Wasserverdrängung.

125

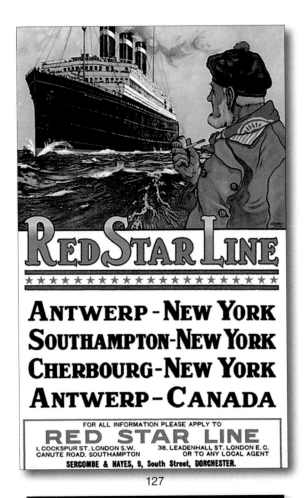

127

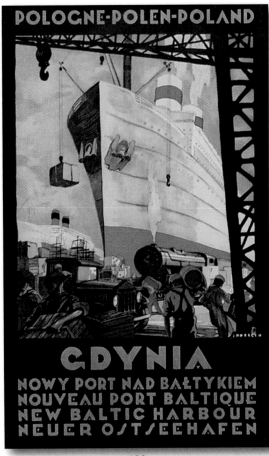

128

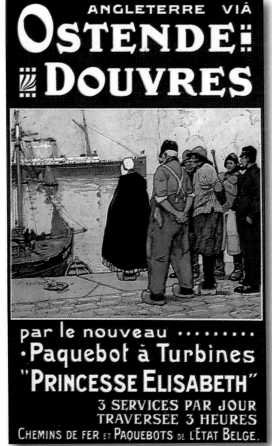

129

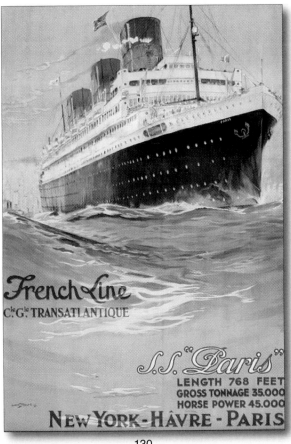

130

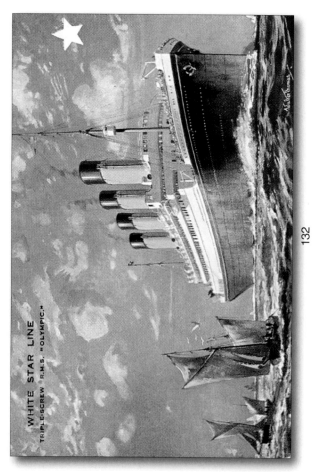

WHITE STAR LINE
TRIPLE-SCREW R.M.S. "OLYMPIC."

132

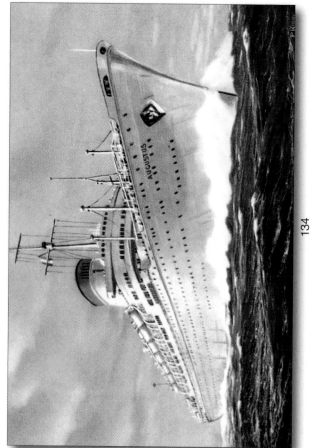

134

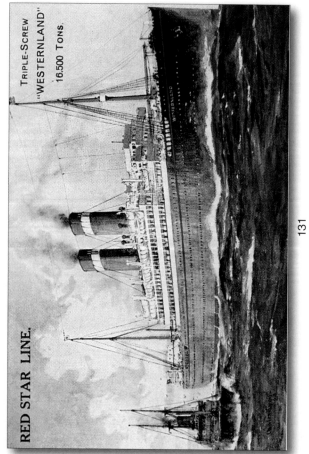

RED STAR LINE.

TRIPLE-SCREW "WESTERNLAND" 16.500 TONS.

131

133

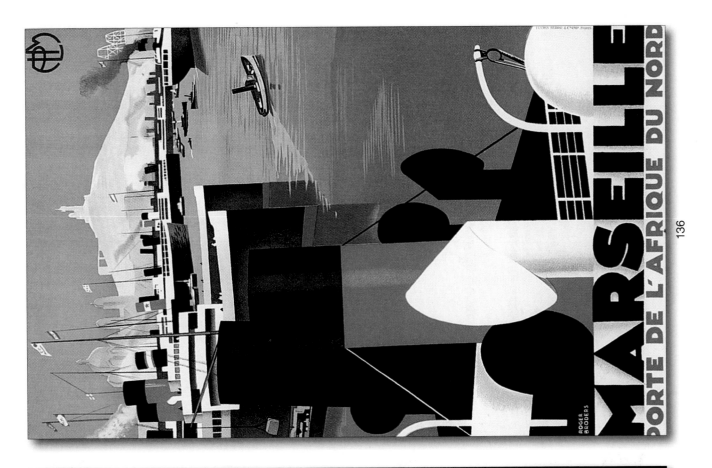

136

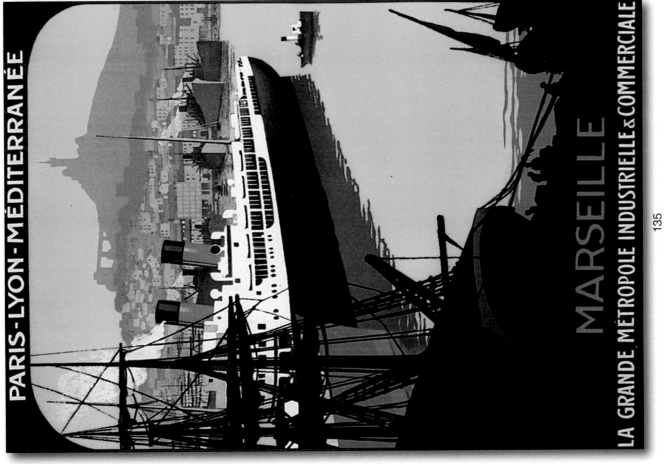

135

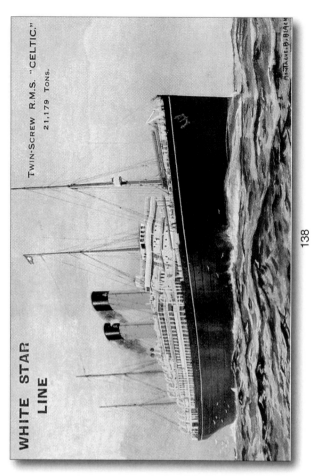

WHITE STAR
LINE

TWIN-SCREW R.M.S. "CELTIC."
21,179 TONS.

138

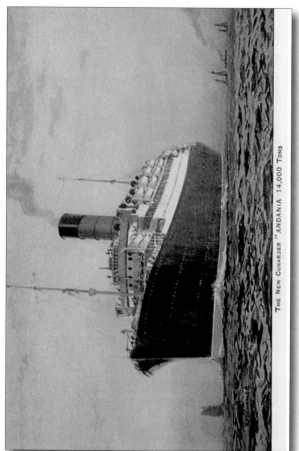

THE NEW CUNARDER "ANDANIA" 14,000 TONS

140

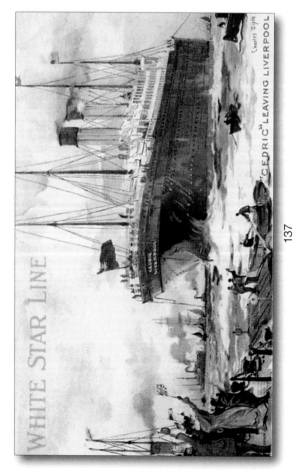

WHITE STAR LINE

"CEDRIC" LEAVING LIVERPOOL

137

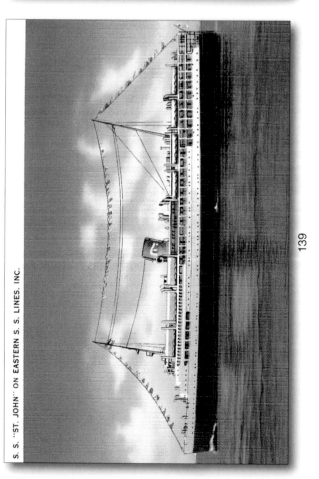

S. S. "ST. JOHN" ON EASTERN S. S. LINES, INC.

139

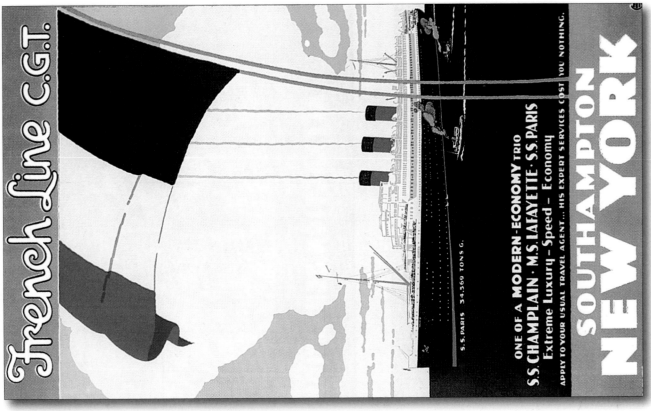

142

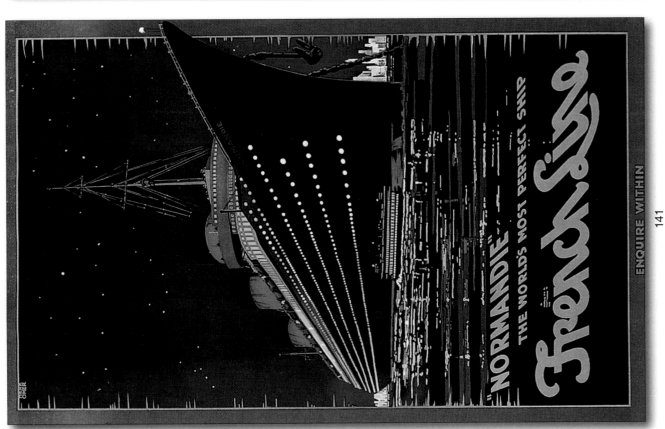

141

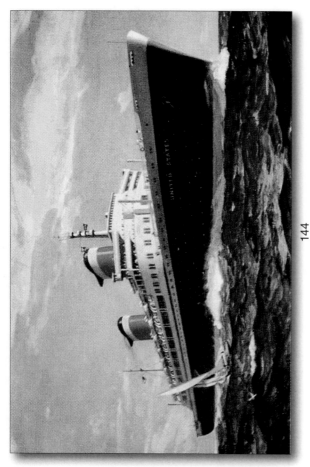

144

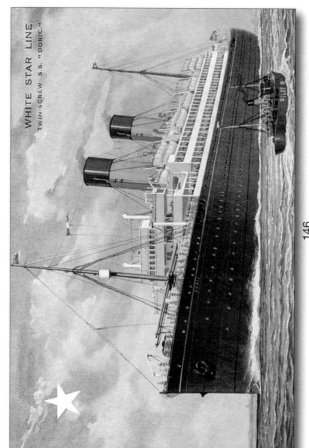

WHITE STAR LINE
TWIN-SCREW S.S. "DORIC."

146

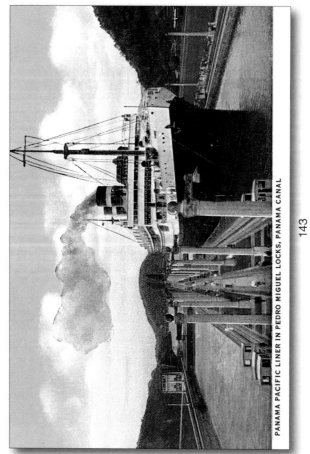

PANAMA PACIFIC LINER IN PEDRO MIGUEL LOCKS, PANAMA CANAL

143

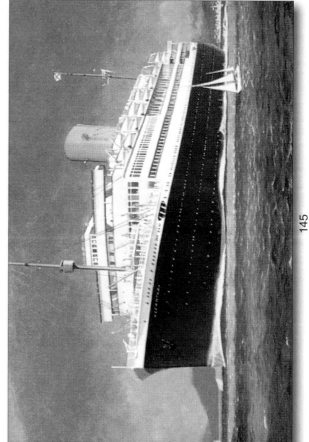

145

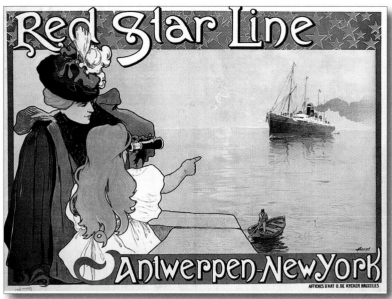

147

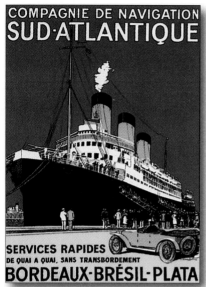

148

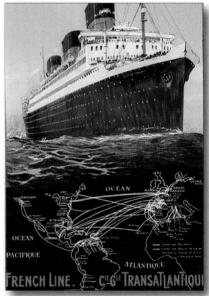

149

150

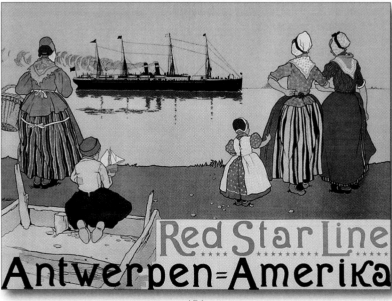

151

152

Hamburg-Amerika Linie

An Bord der „Amerika" den

154

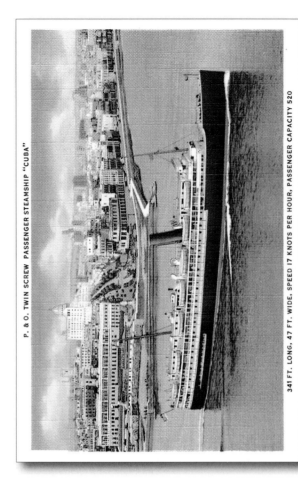

P. & O. TWIN SCREW PASSENGER STEAMSHIP "CUBA"

341 FT. LONG, 47 FT. WIDE, SPEED 17 KNOTS PER HOUR, PASSENGER CAPACITY 520

156

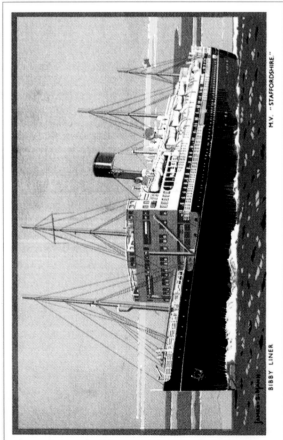

M.V. "STAFFORDSHIRE."

BIBBY LINER

153

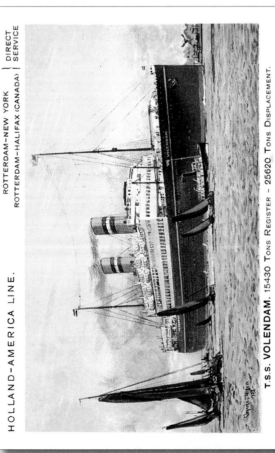

HOLLAND-AMERICA LINE.

ROTTERDAM—NEW YORK } DIRECT
ROTTERDAM—HALIFAX (CANADA) } SERVICE

T.S.S. VOLENDAM. 15430 TONS REGISTER – 25620 TONS DISPLACEMENT.

155

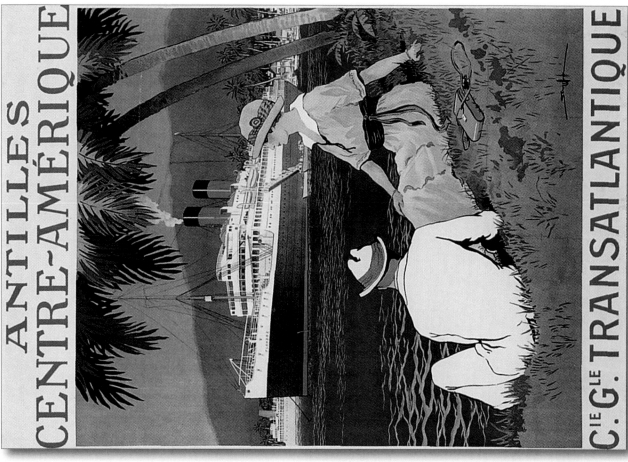

158

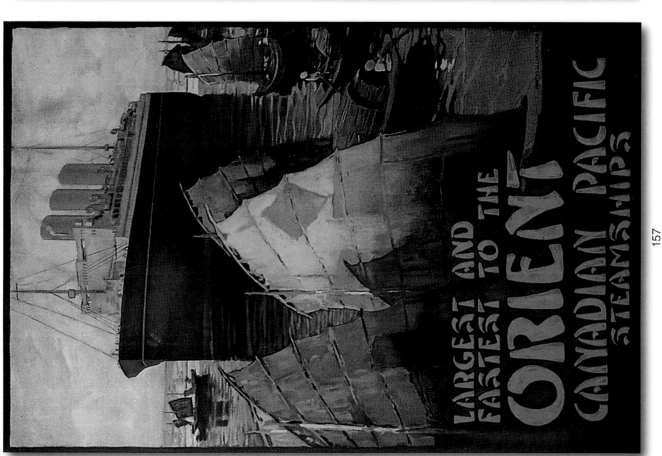

157

45

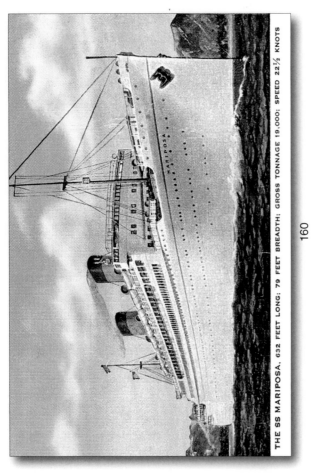

THE SS MARIPOSA, 632 FEET LONG; 79 FEET BREADTH; GROSS TONNAGE 19,000; SPEED 22½ KNOTS

160

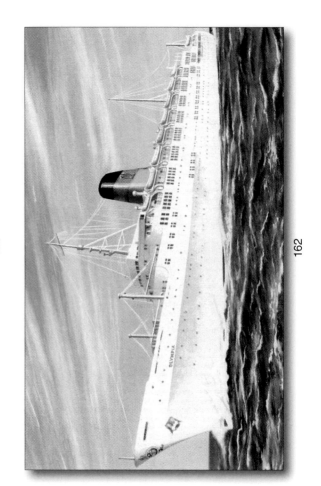

162

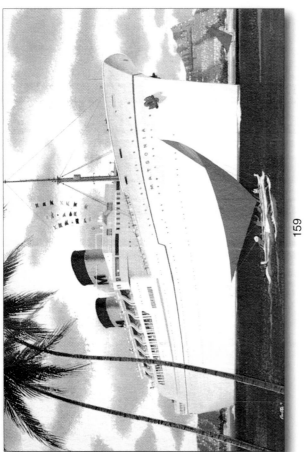

159

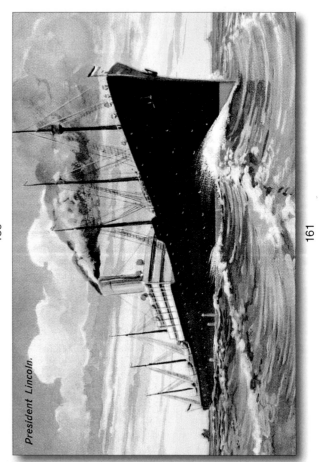

President Lincoln.

161

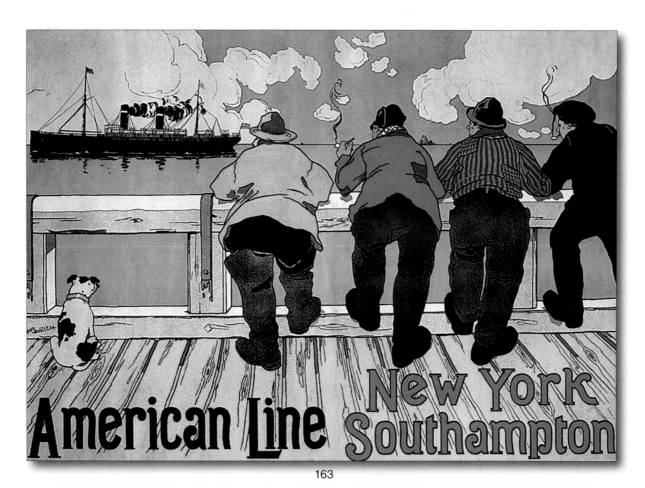

163

The New White Star Liner,
R.M.S. "TITANIC"

provides for her first-class passengers
VINOLIA OTTO TOILET SOAP
the highest standard of Toilet Luxury and comfort at sea.

VINOLIA COMPANY LTD., LONDON AND PARIS.

164

47

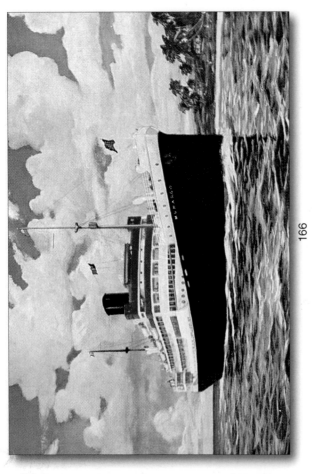

166

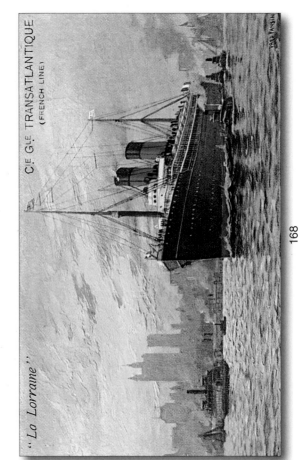

"La Lorraine"

C.ⁱᵉ G.ᵗᵉ TRANSATLANTIQUE
(FRENCH LINE)

168

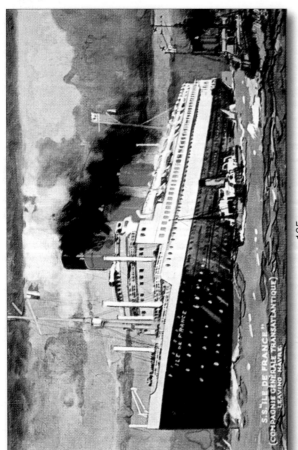

S.S."ILE DE FRANCE"
(COMPAGNIE GÉNÉRALE TRANSATLANTIQUE)
LEAVING HAVRE

165

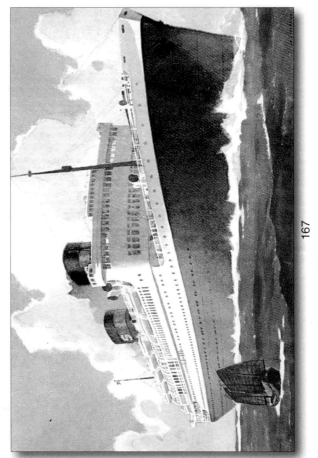

167